DRAW 500

WAYS TO

GET AROUND

A Sketchbook for Artists, Designers, and Doodlers

JAMES GULLIVER HANCOCK

QUARRY

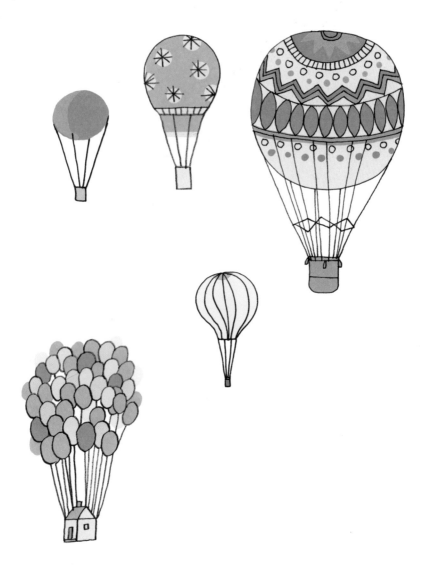

HOW TO USE THIS BOOK

Draw 500 Ways to Get Around encourages you to see things differently, using drawing materials and tools in different ways. We are all unique, and everyone has their own pace and path to take.

We all draw for different reasons—to gather information for a more elaborate piece of art, to understand how something is constructed, to plan something out, or to explain our ideas visually. Perhaps most of all, we draw for the pure joy that making marks on paper gives to us.

In this book you will find space on the opposite page or in between the drawings for you to add your own artwork. You may want to start by copying a few of my drawings to get the feeling for how the object is constructed, or you may want to just adapt my renderings to invent your own. The idea of this book is to provide different mark-making approaches and ways of simplifying a subject to capture the feel of it—whether it's a train, zeppelin, or jet pack.

A good way to start is to draw the main line that supports an object. So, for a bicycle, say, begin by drawing the shape of the bike frame, and then you can add the wheels, seat, handlebars, and other details. Every copy of this book starts off identically, but if you fill this book with your ideas and your own marks it will become uniquely *yours!*

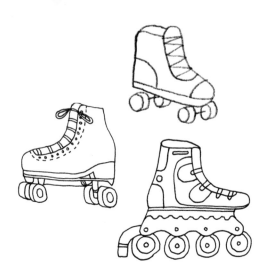

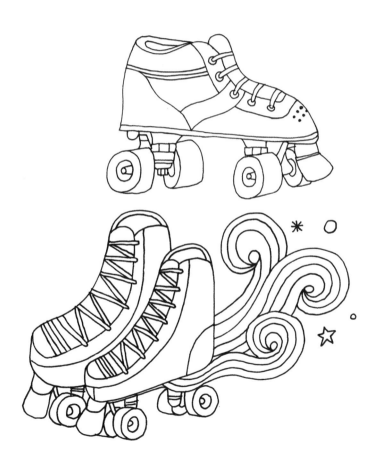

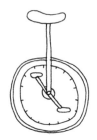

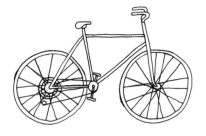

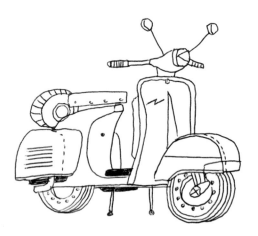

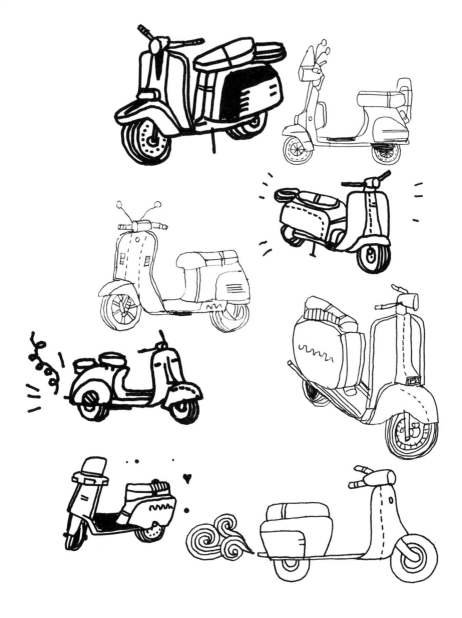

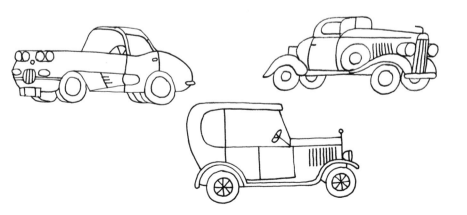

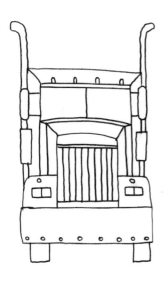

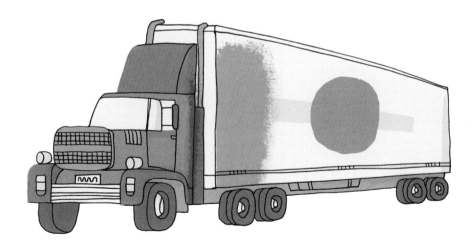

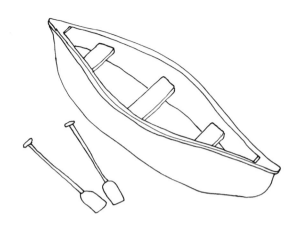

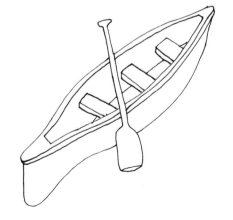

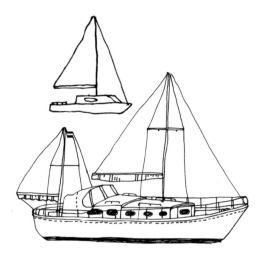

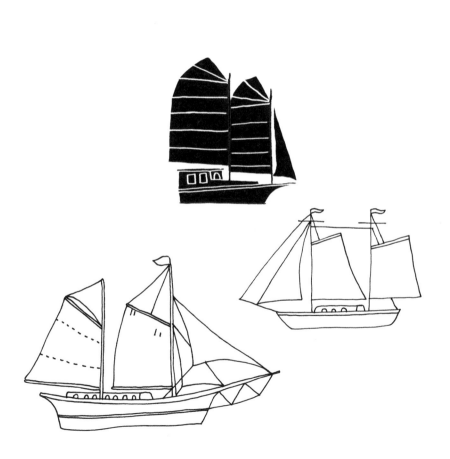

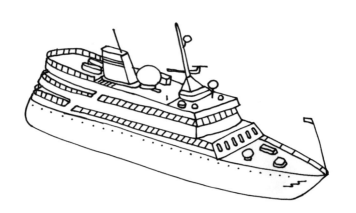

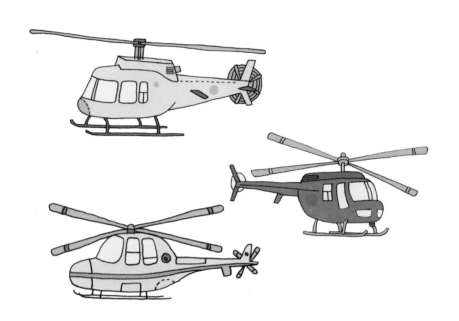

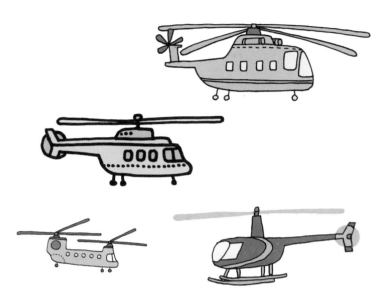

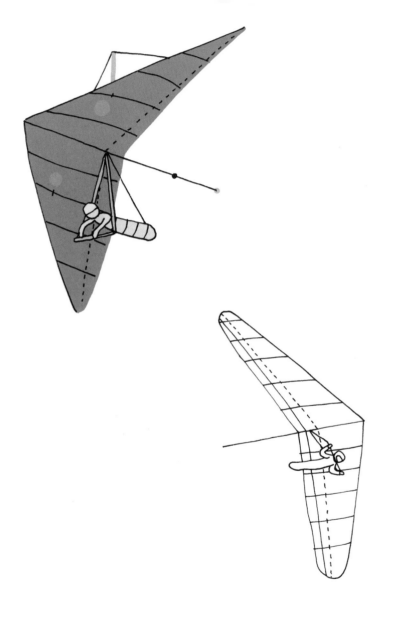

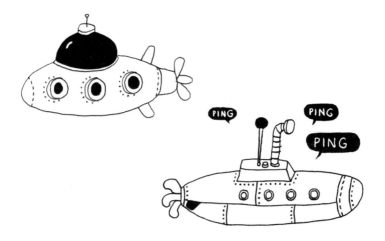

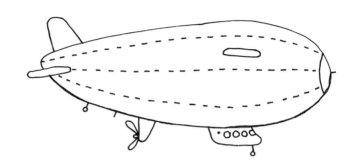

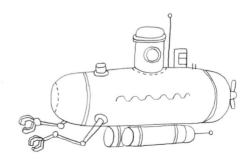

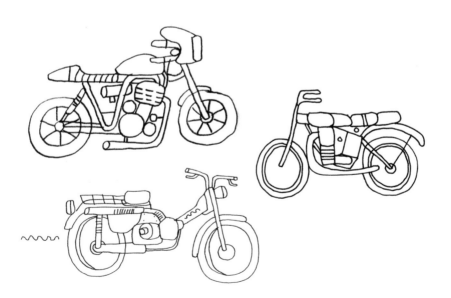

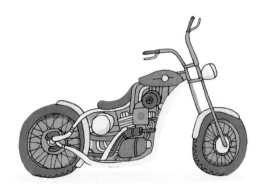

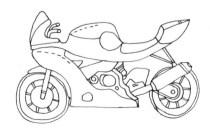

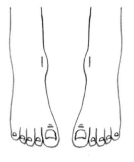

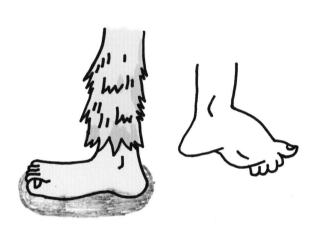

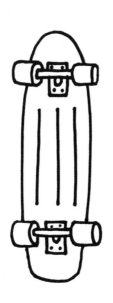

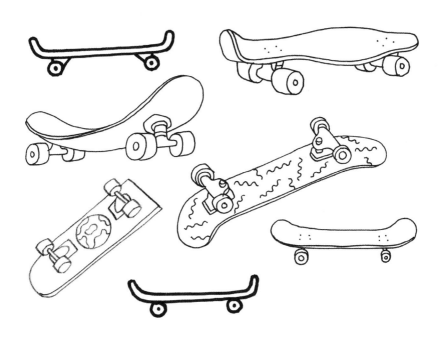

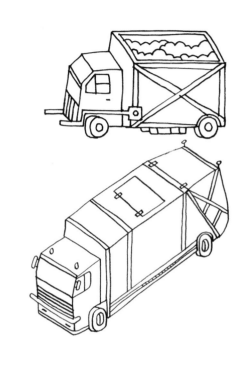
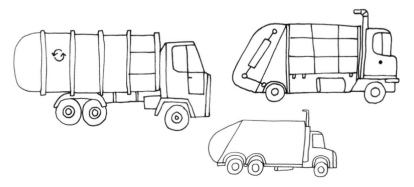

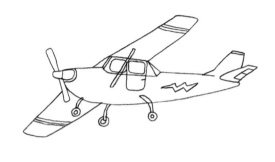

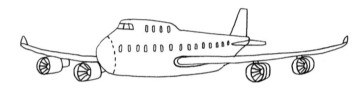

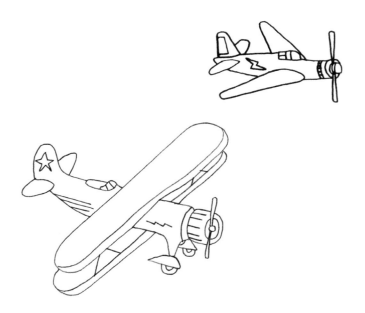

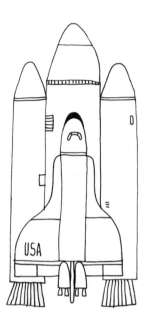
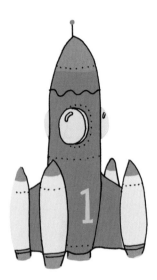

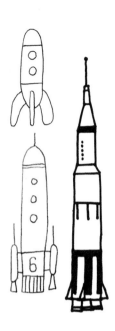

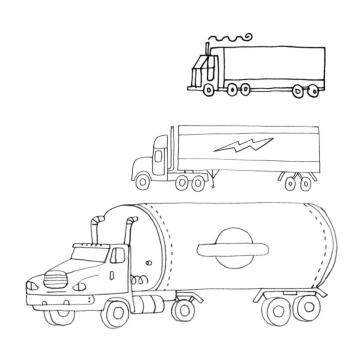

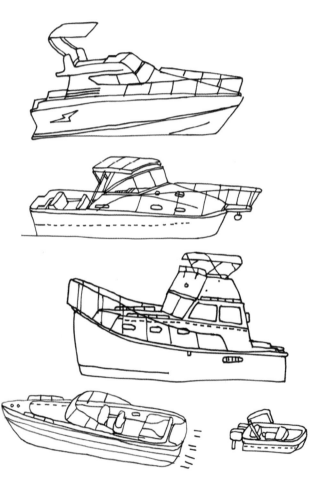

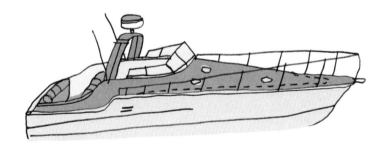

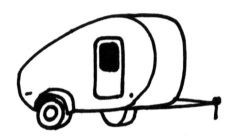

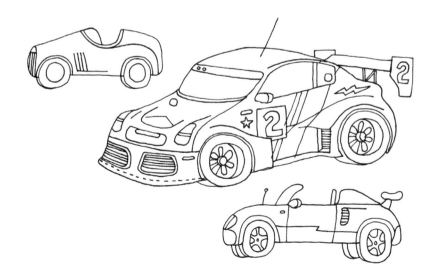

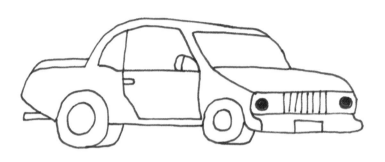

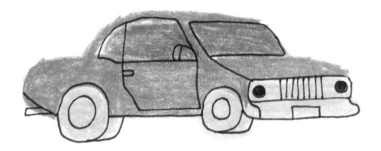

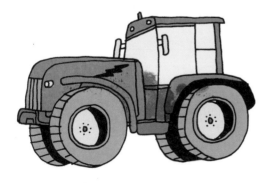

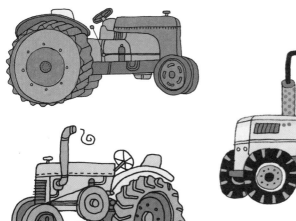
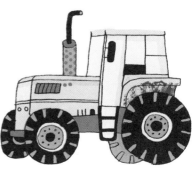

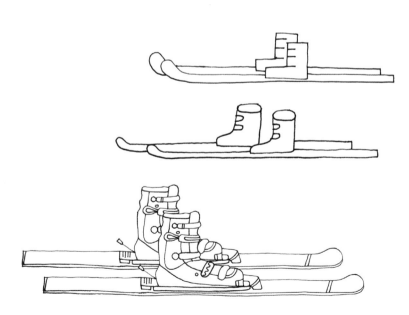

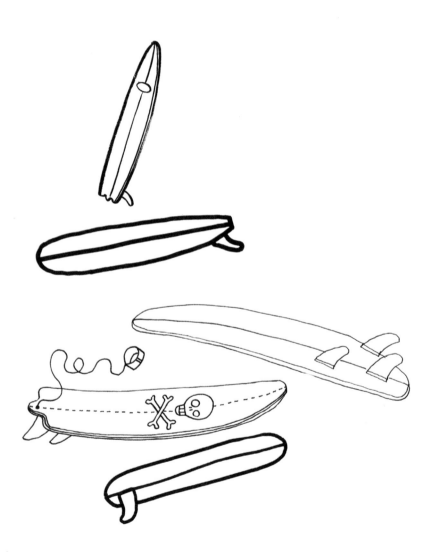

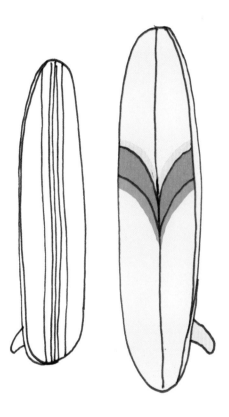

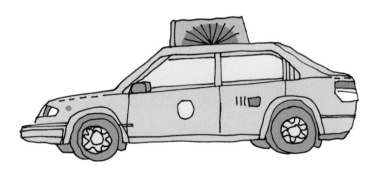

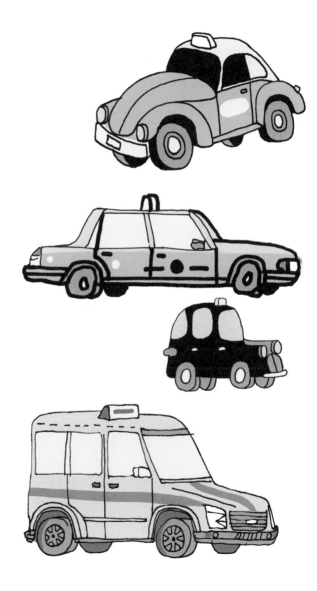

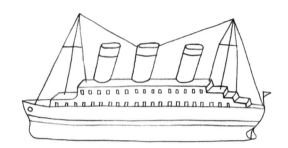

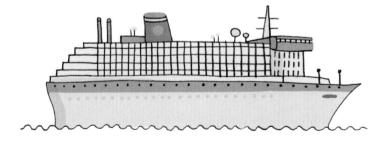

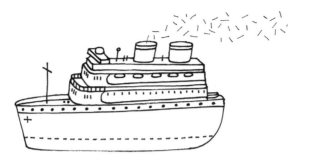

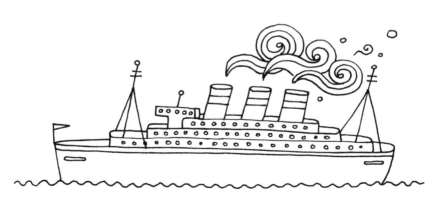

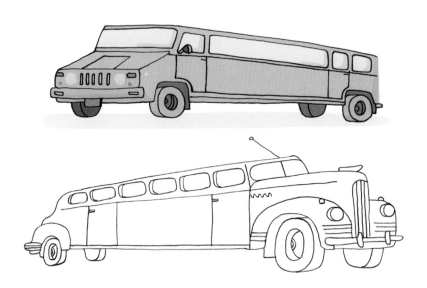

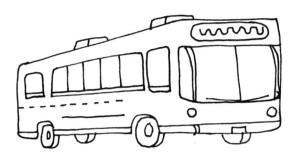

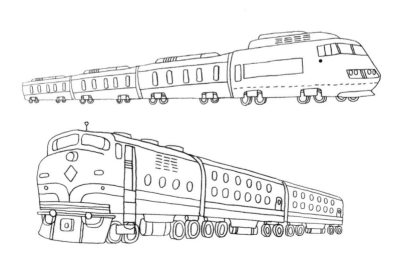

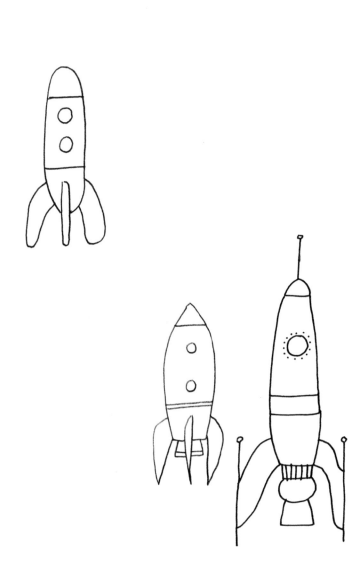

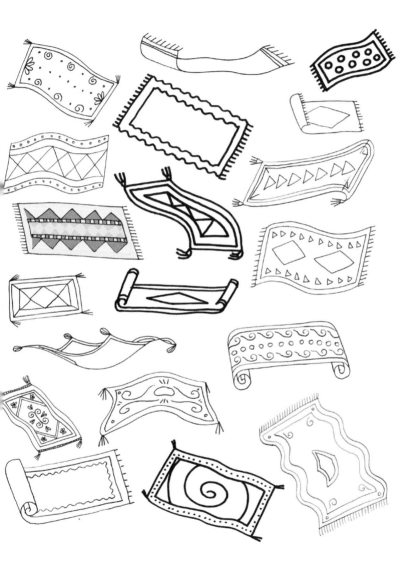

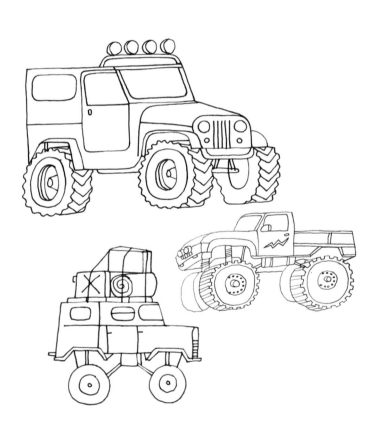

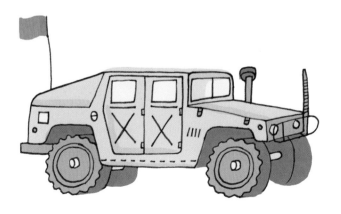

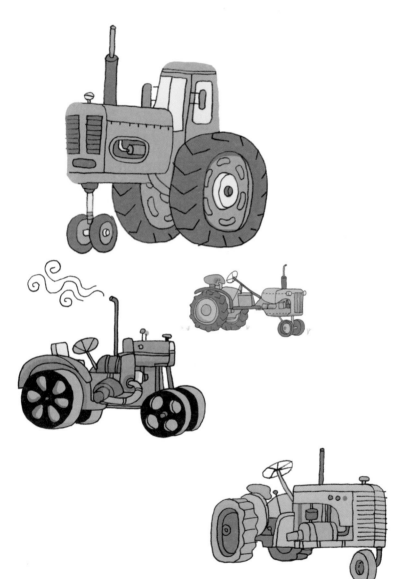

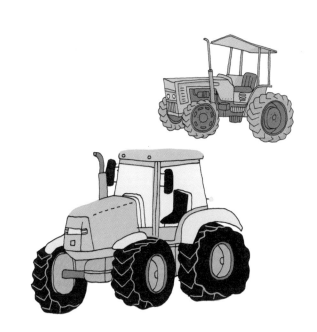

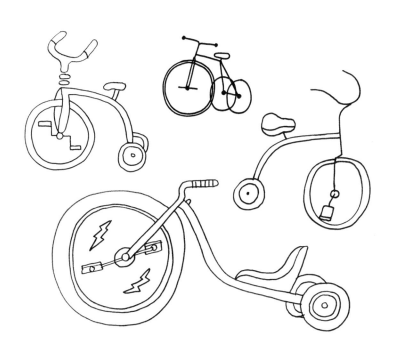

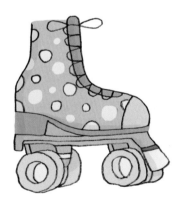
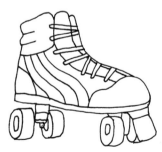

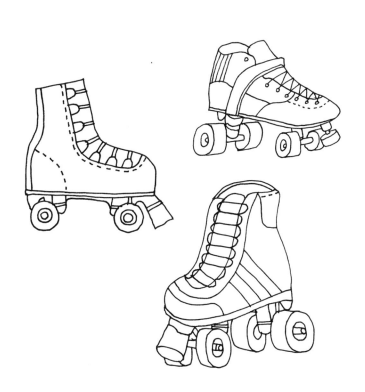

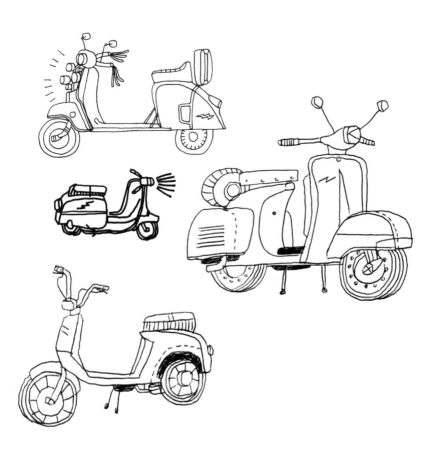

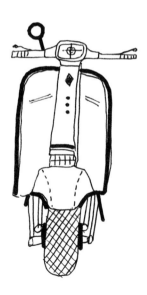

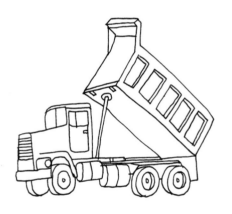

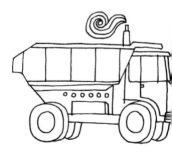

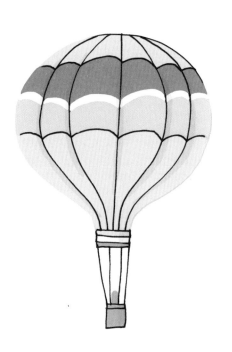

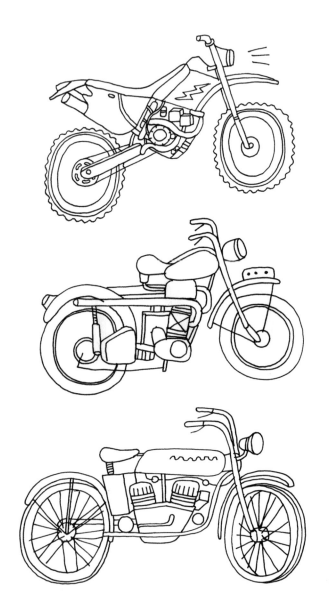

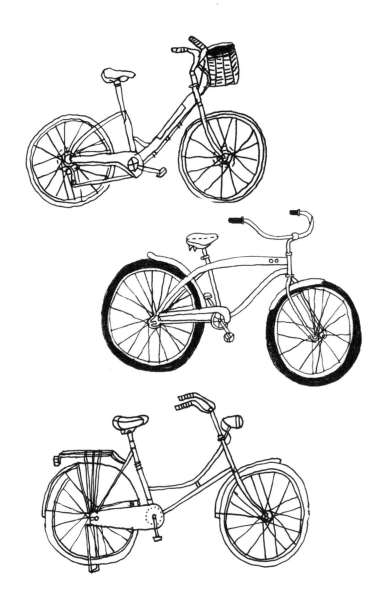

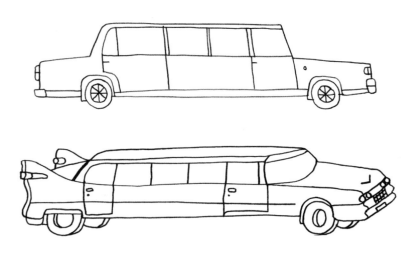

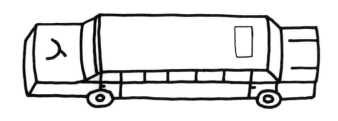

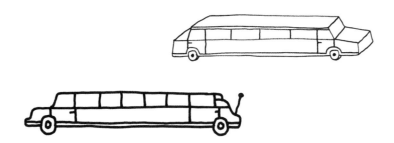

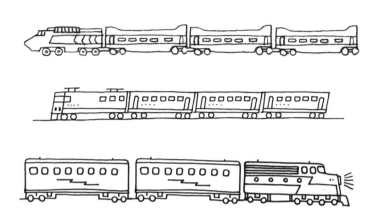

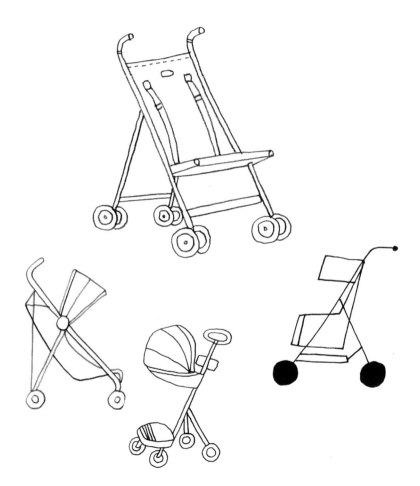

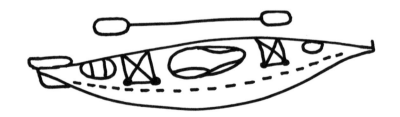

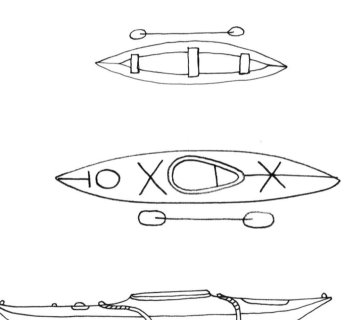

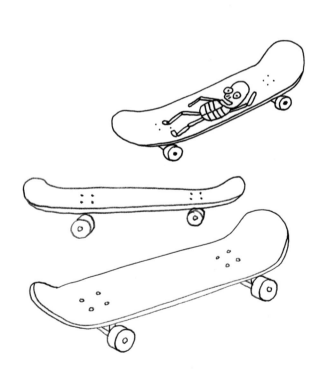

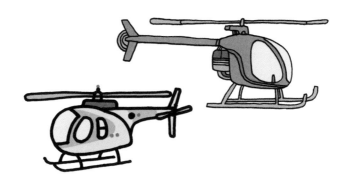

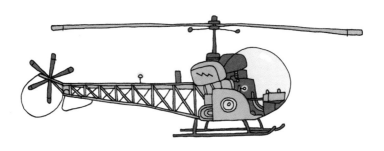

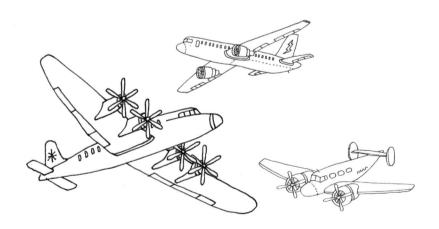

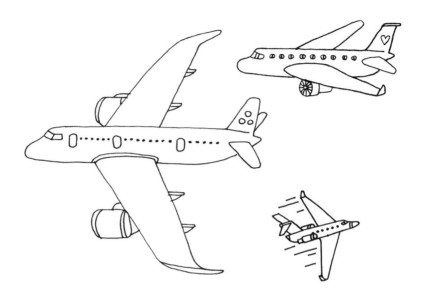

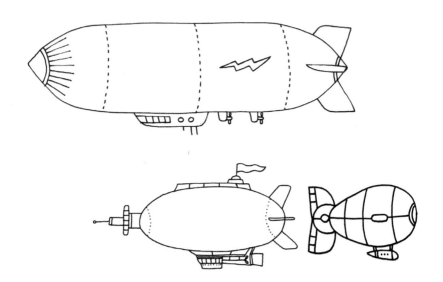

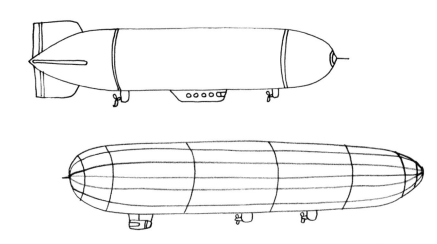

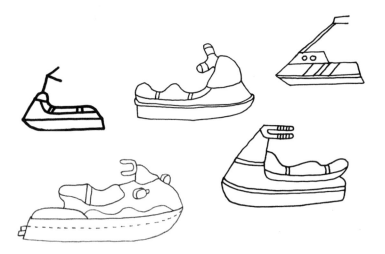

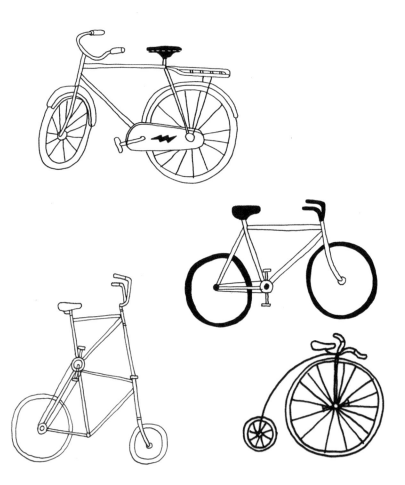

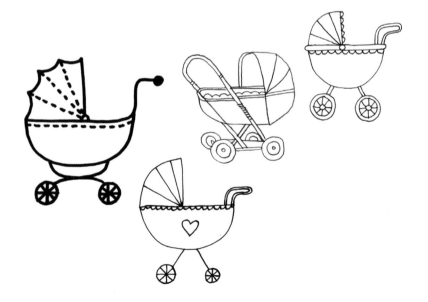

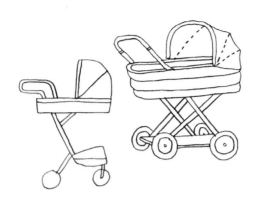

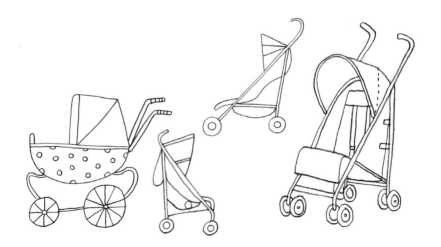

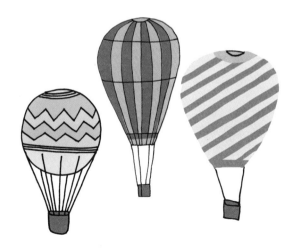

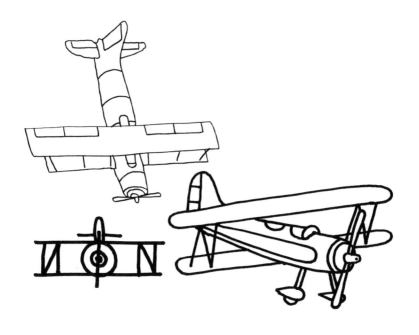

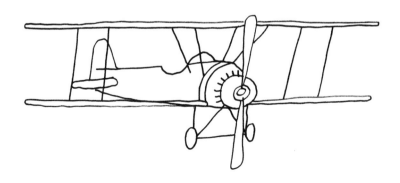

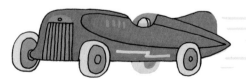

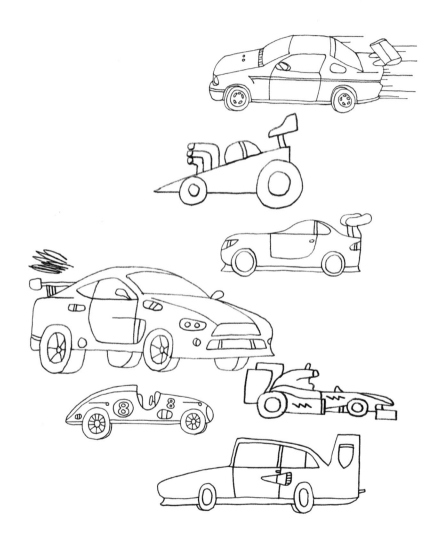

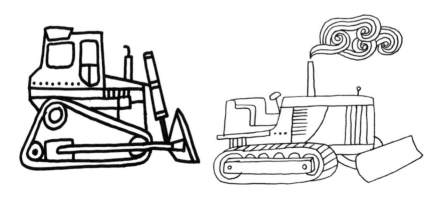

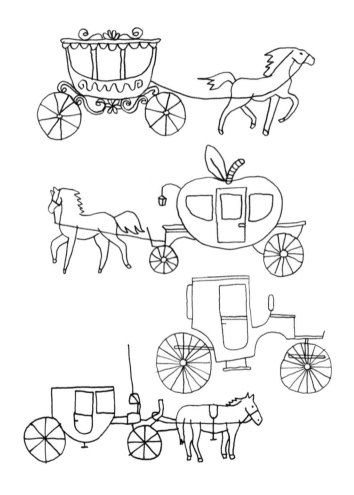

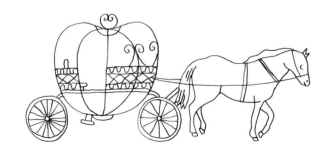

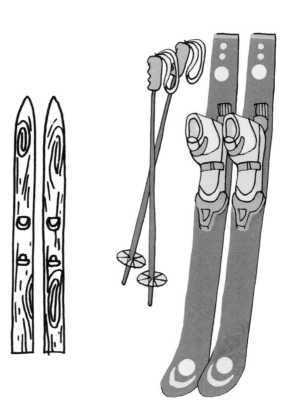

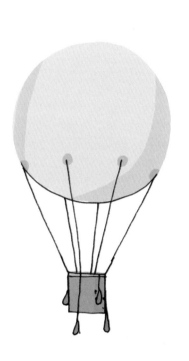

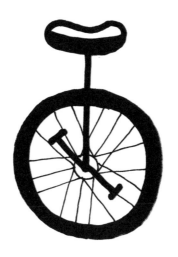

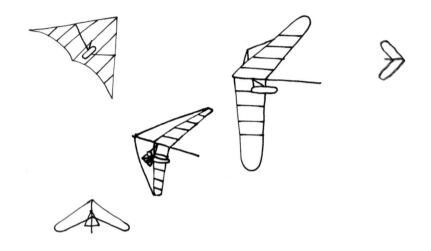

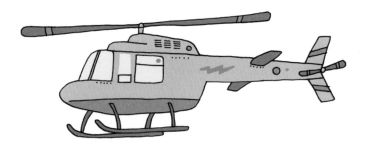

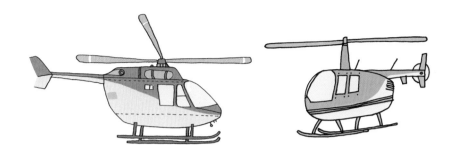

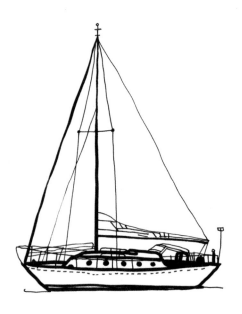

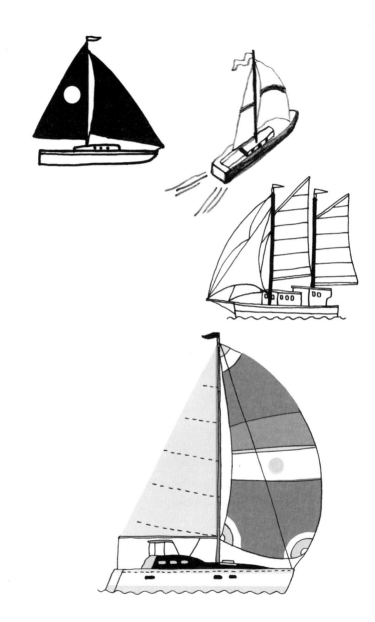

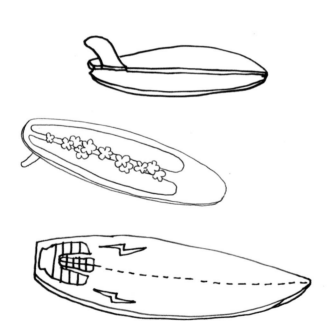

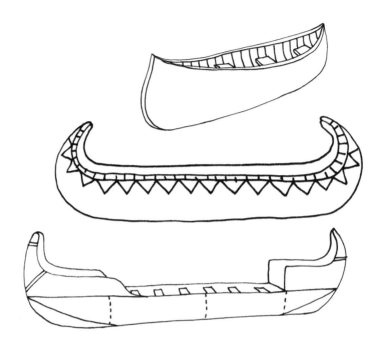

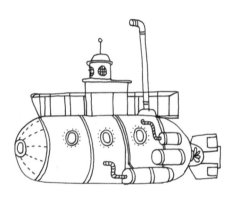

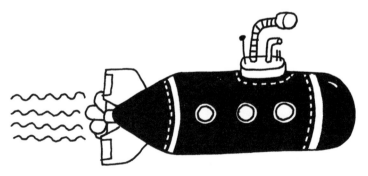

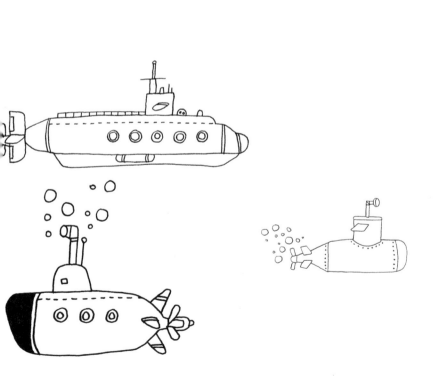

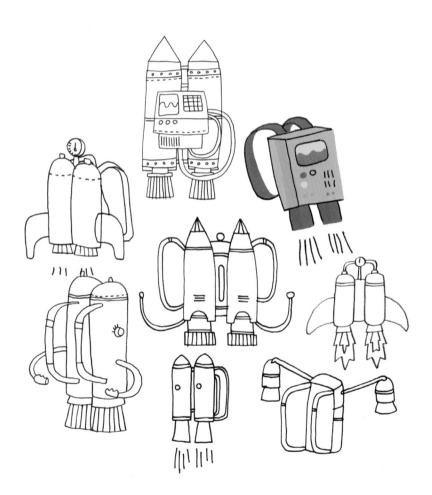

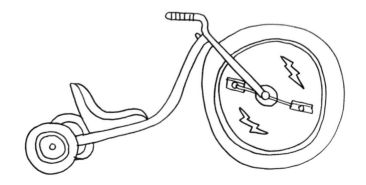

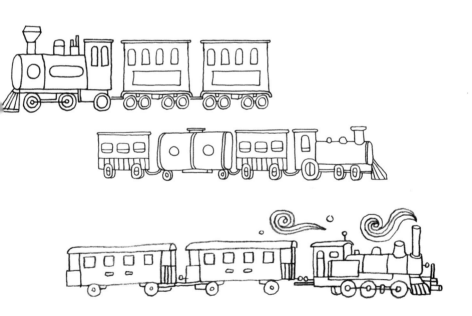

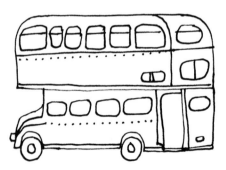

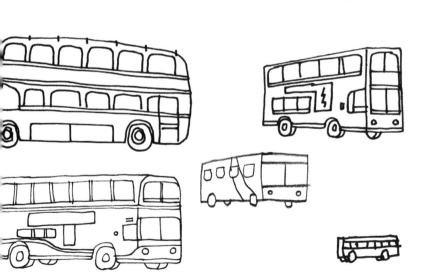

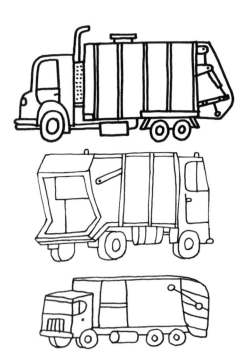

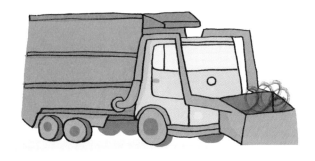

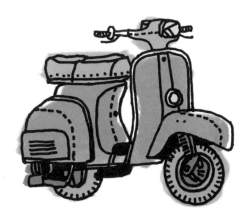

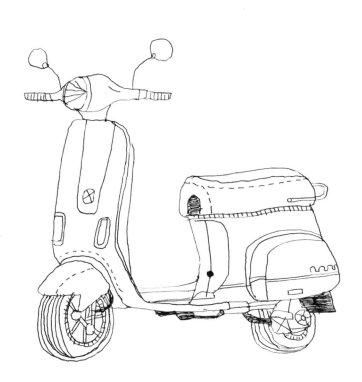

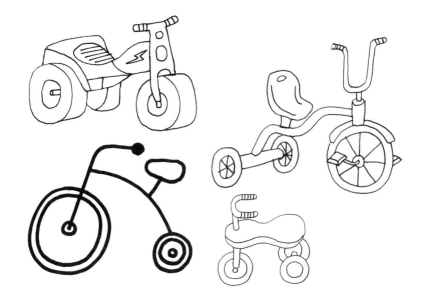

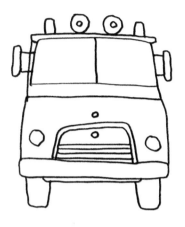

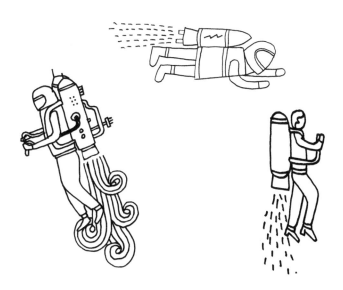

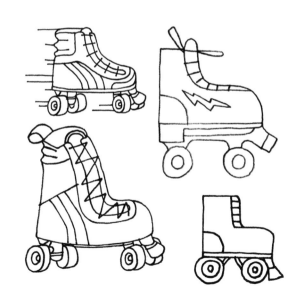

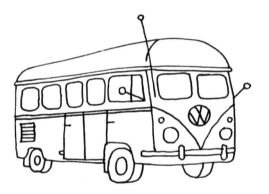

ABOUT THE ARTIST

James Gulliver Hancock is an international illustrator well known for his ambitious project www.allthebuildingsinnewyork.com. Born in Sydney, Australia, James has lived all over the world, taking his whimsical perception to places such as Austria, Indonesia, the UK, France, and the USA. He studied visual communication in Sydney and is obsessed with drawing everything around him. *20 Ways to Draw a Bicycle* is a perfect fit for him as he feels everyone should draw the things around them to gain a fuller appreciation of the things they use every day. He lives between Sydney and Brooklyn and has a two-year-old son that is obsessed with anything with wheels—this one's for you Quinn!

You can see more of James' work at www.jamesgulliverhancock.com and www.allthebuildingsinnewyork.com.

Quarto is the authority on a wide range of topics.

Quarto educates, entertains and enriches the lives of our readers—enthusiasts and lovers of hands-on living.

www.QuartoKnows.com

First published in the United States of America in 2016 by
Quarry Books, a member of
Quarto Publishing Group USA Inc.
100 Cummings Center
Suite 406-L
Beverly, Massachusetts 01915-6101
Telephone: (978) 282-9590
Fax: (978) 283-2742
QuartoKnows.com
Visit our blogs at QuartoKnows.com

10 9 8 7 6 5 4 3 2 1

ISBN: 978-1-63159-253-9

All artwork compiled from *20 Ways to Draw a Bike and 44 Other Incredible Ways to Get Around*, © 2015 Quarry Books

Design: Debbie Berne

Printed in China